"Macabre, Monsters and Mayhem"

*I want to thank you to all my fans for all your encouragement.
By popular demand I have created this horror book.
Growing up I was always labeled a Goth chick so of course
creating nightmares such as these came very easily to me.
As always I want to dedicate this book to my babies.
Their love keeps me going and creating, they are my world.
I also want to thank my new friend Sarah Rowan for
all her input in helping make this book possible.
This book is not for the faint of heart so be warned and color
at your own risk!*

*Follow me at:
https://www.facebook.com/daydreamingcoloringbooks/
for freebies, contests and more!*

*Make sure to check out my other books already
availible on Amazon.com*

**ISBN-13:978-1539570998
ISBN-10:1539570991**

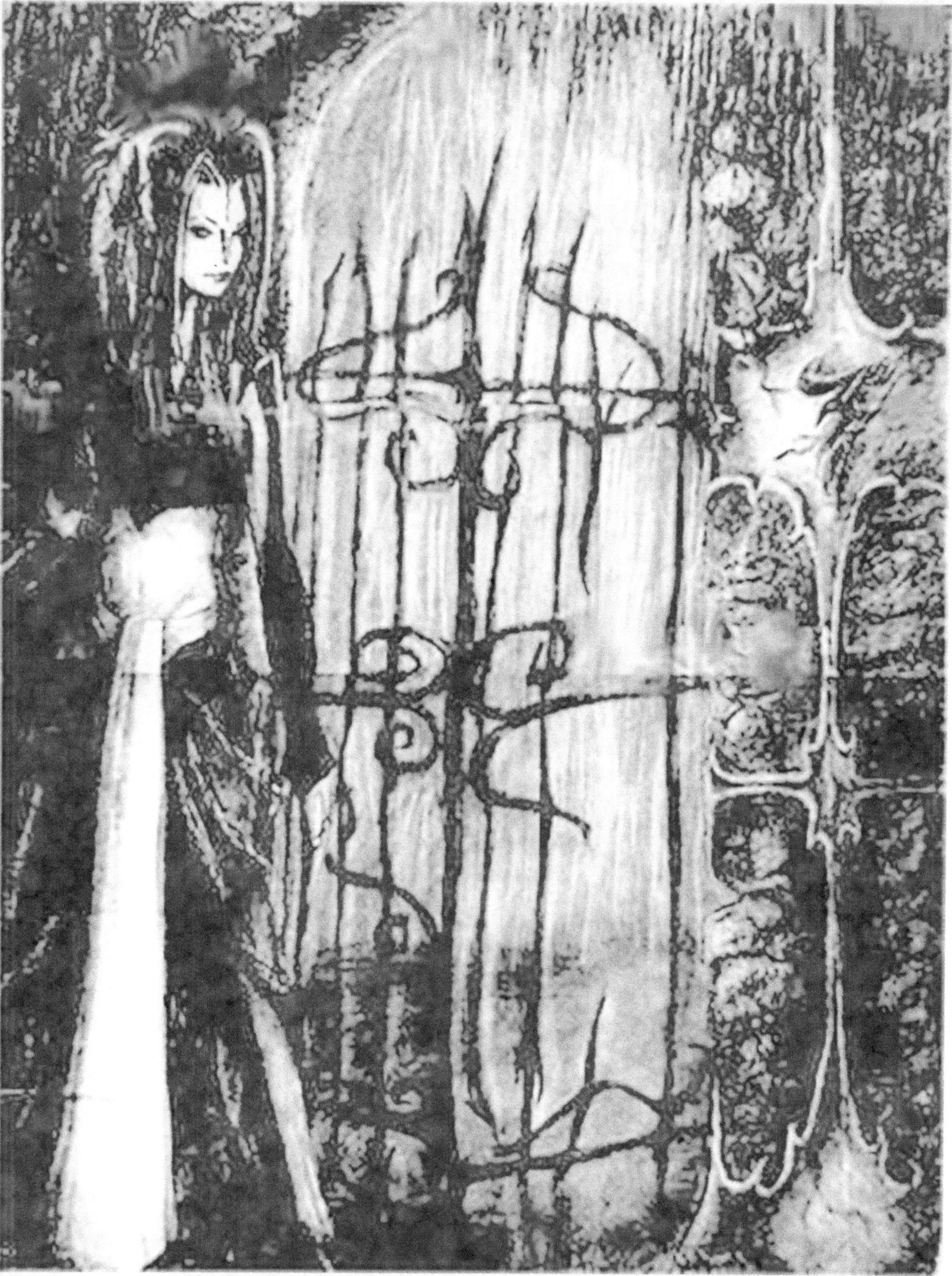

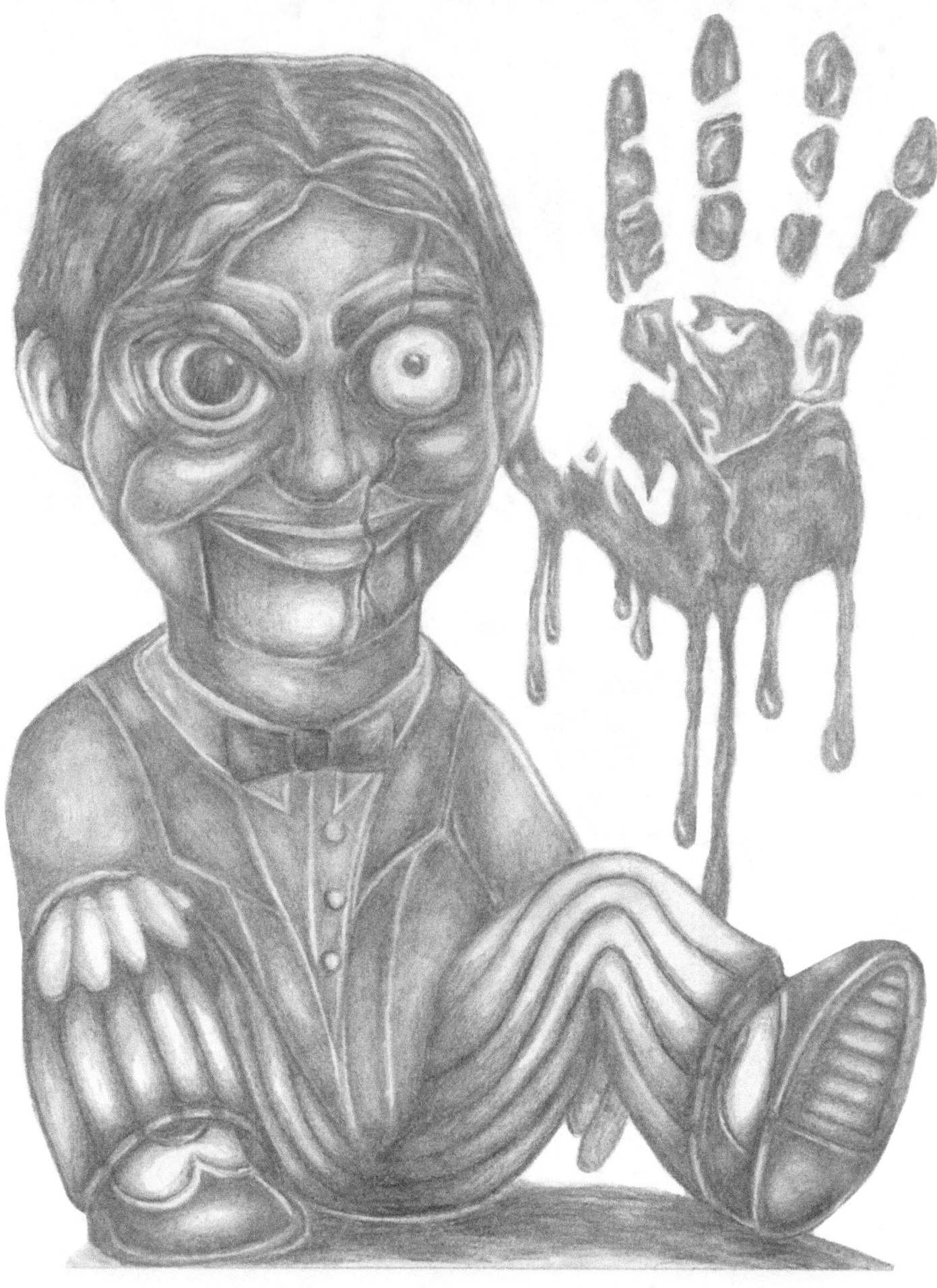

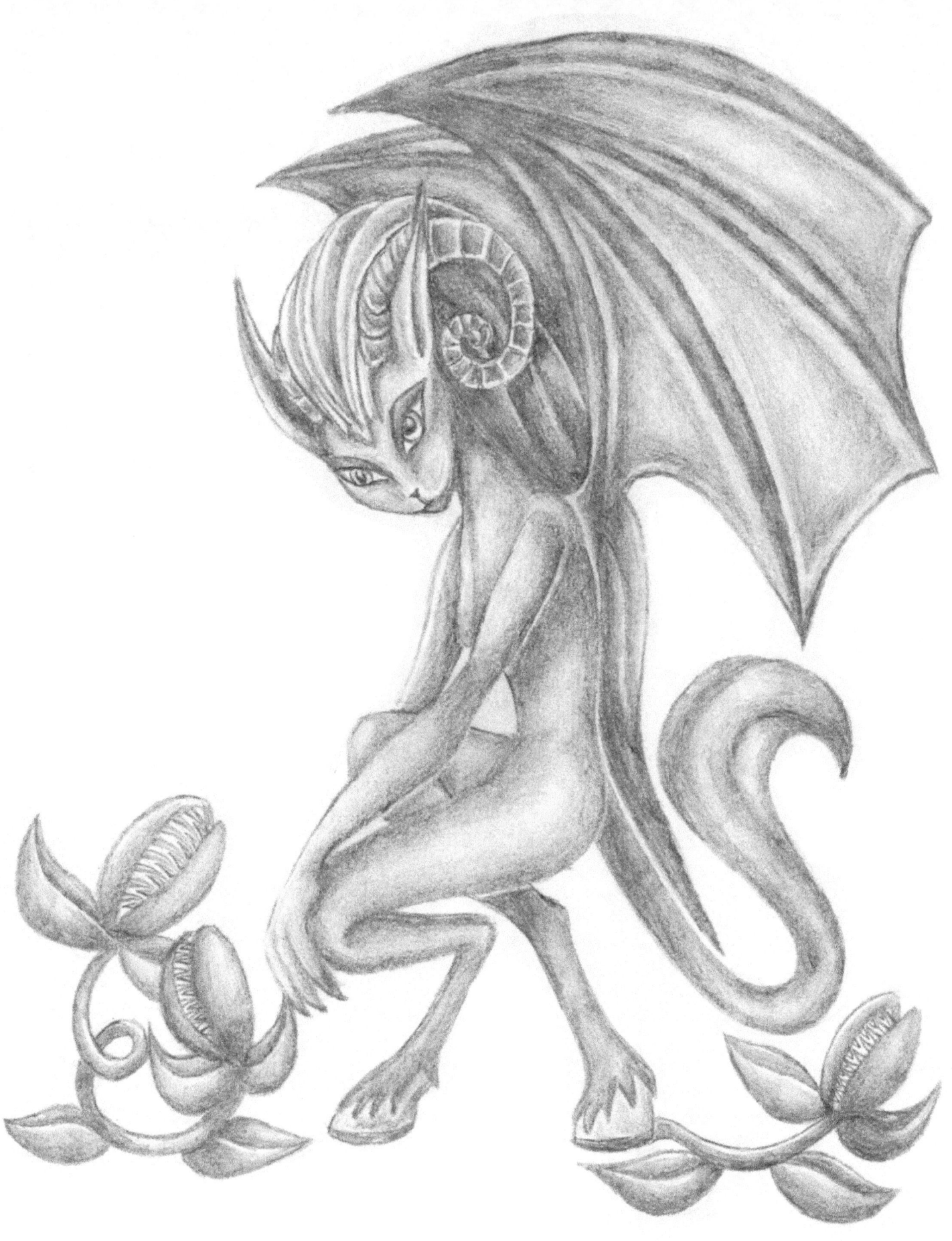

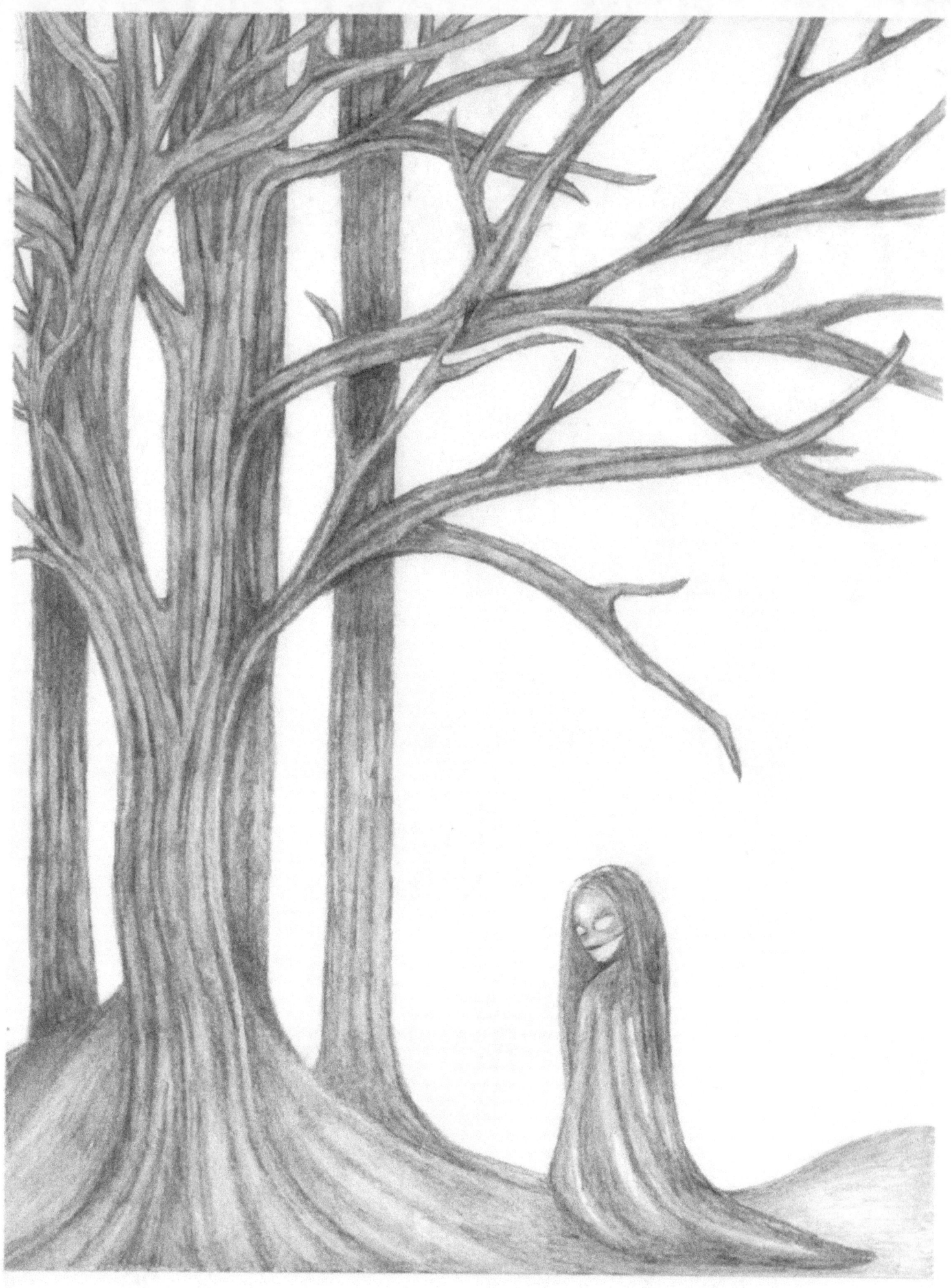

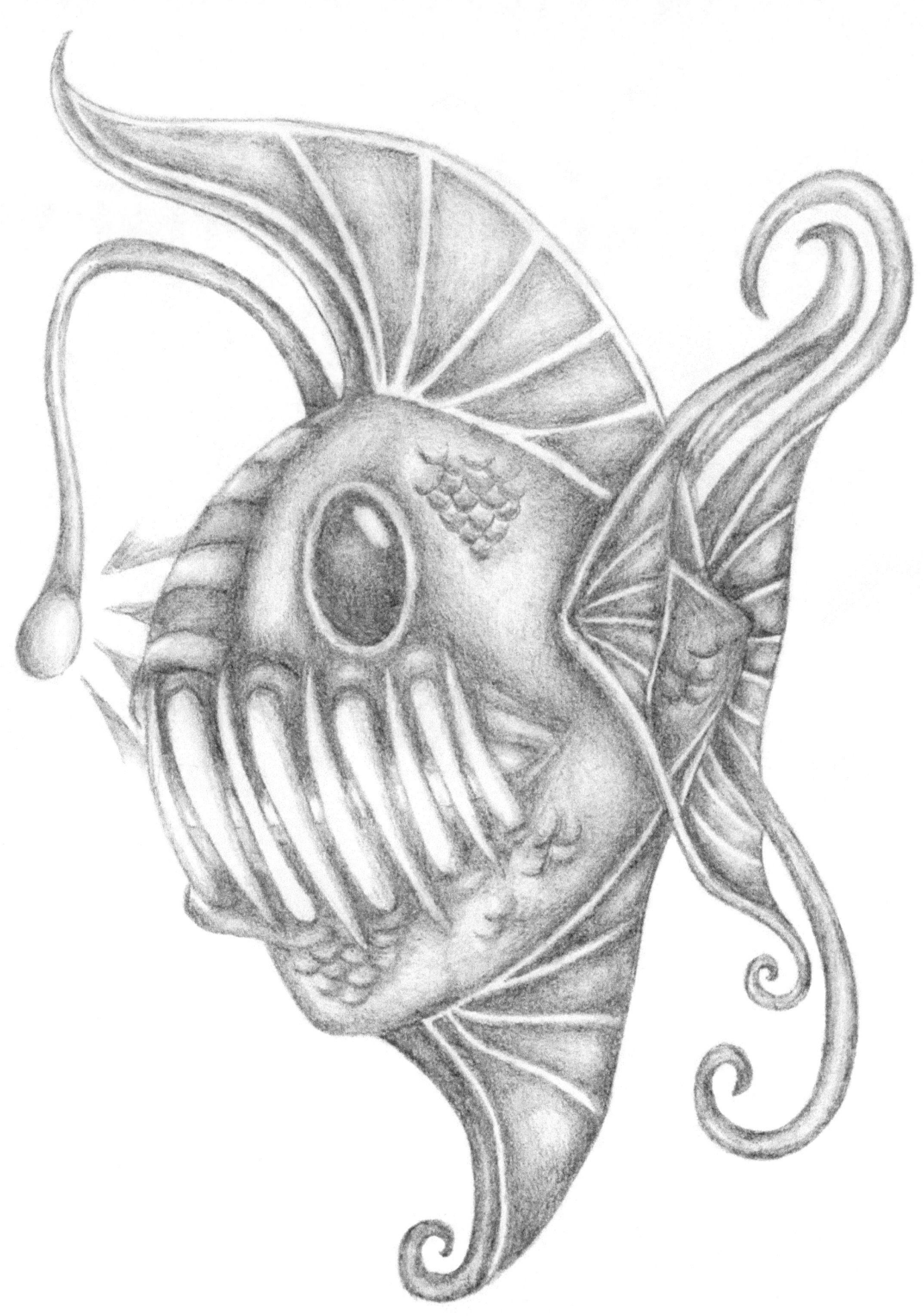

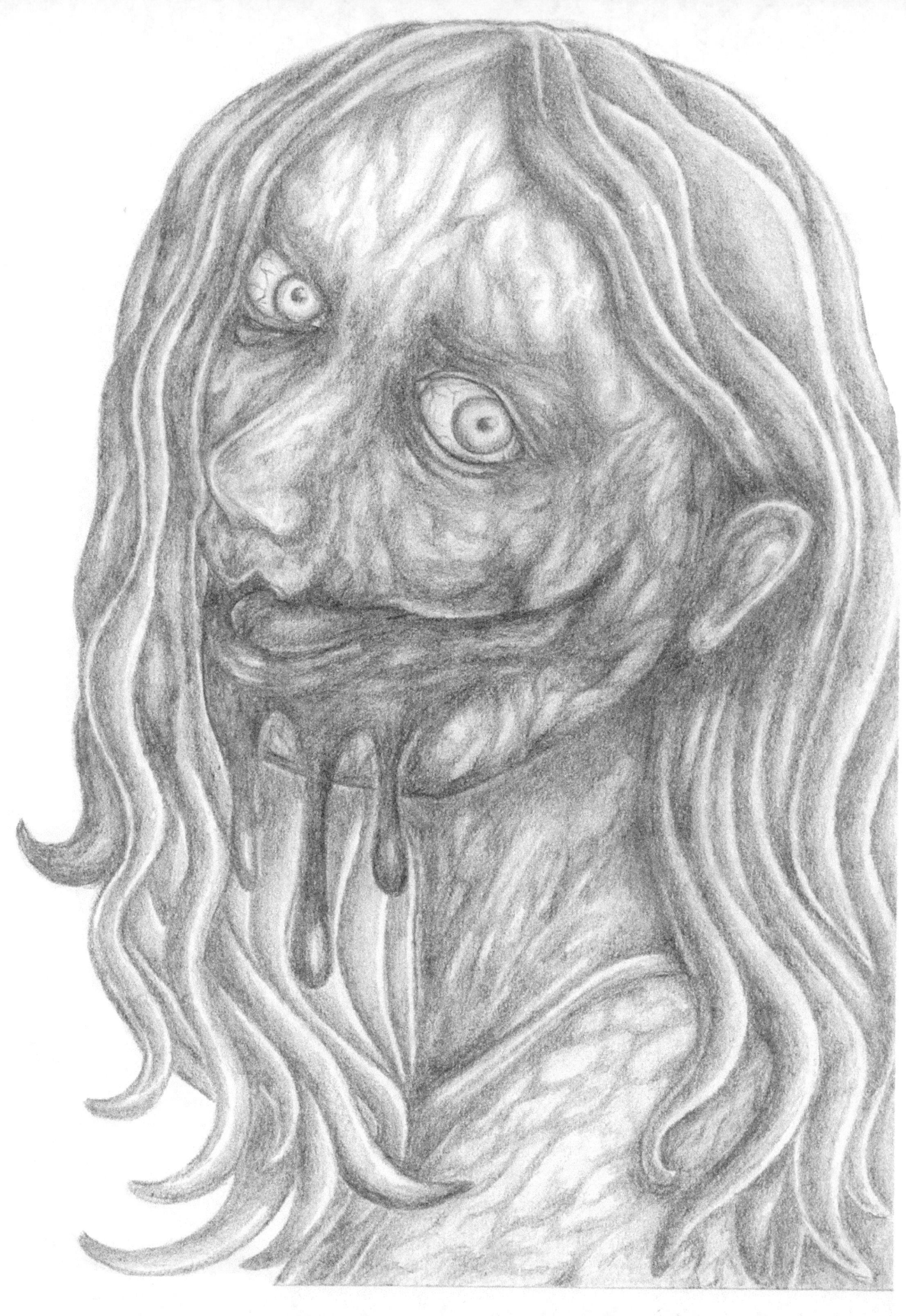

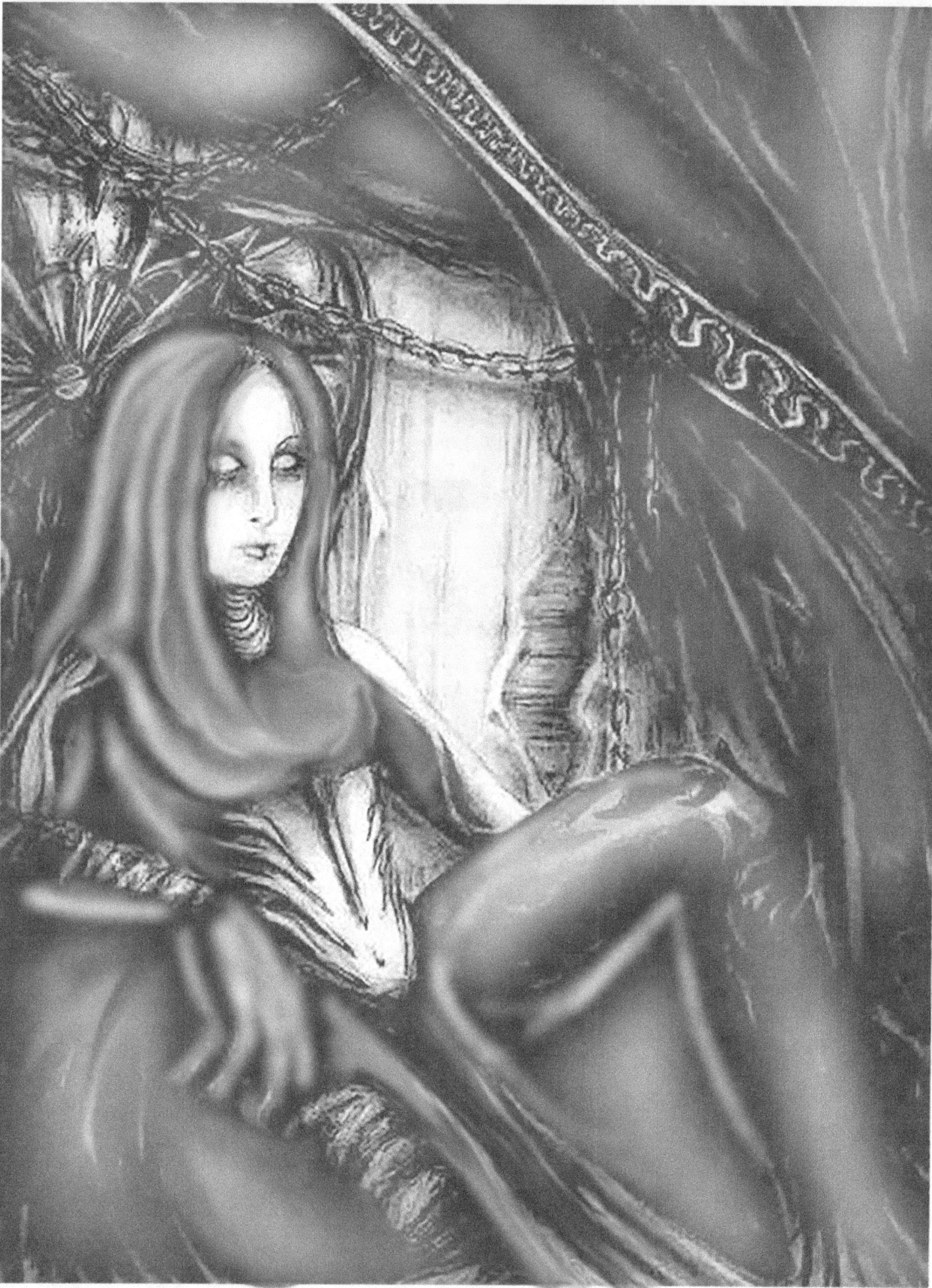

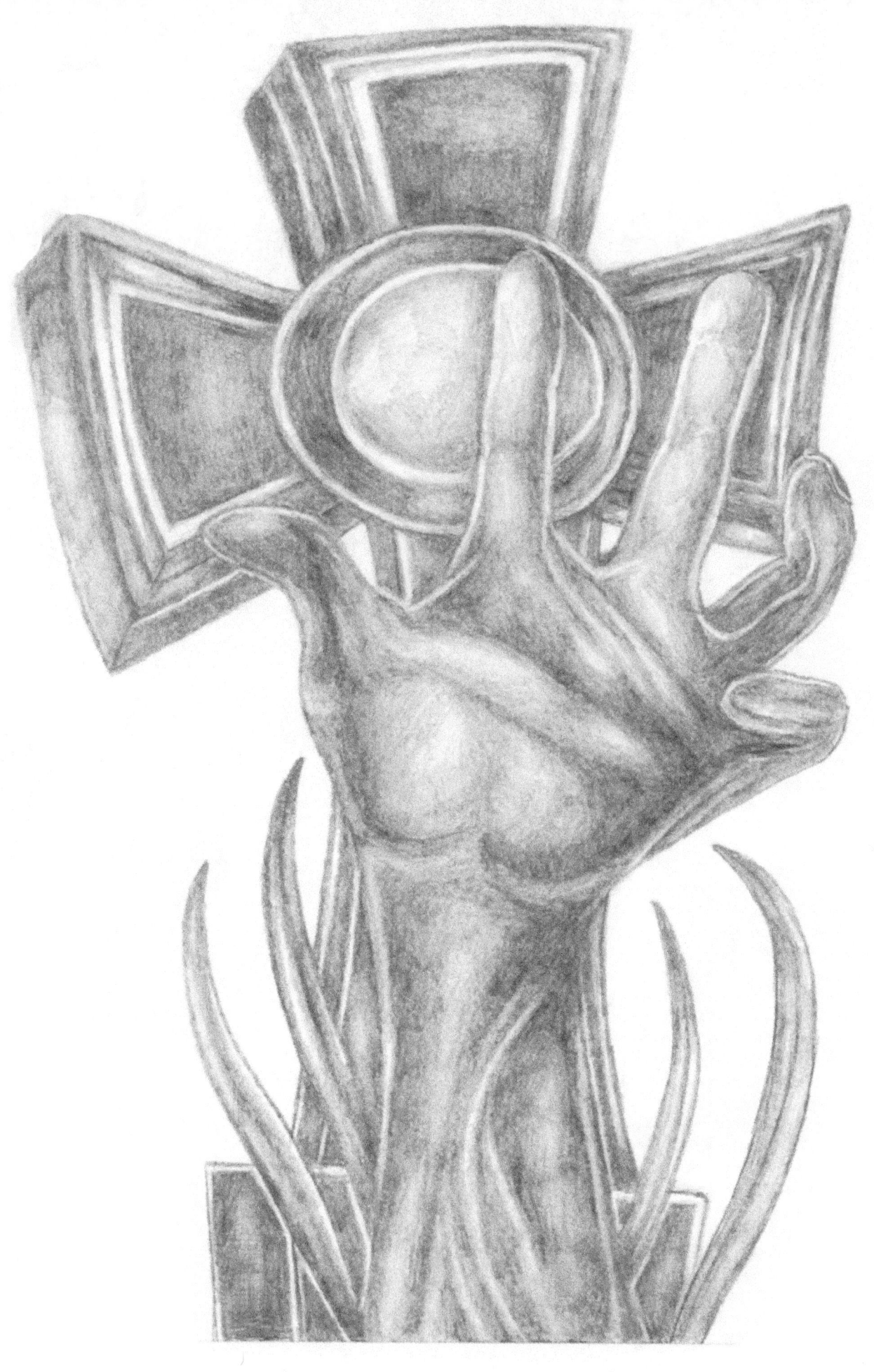

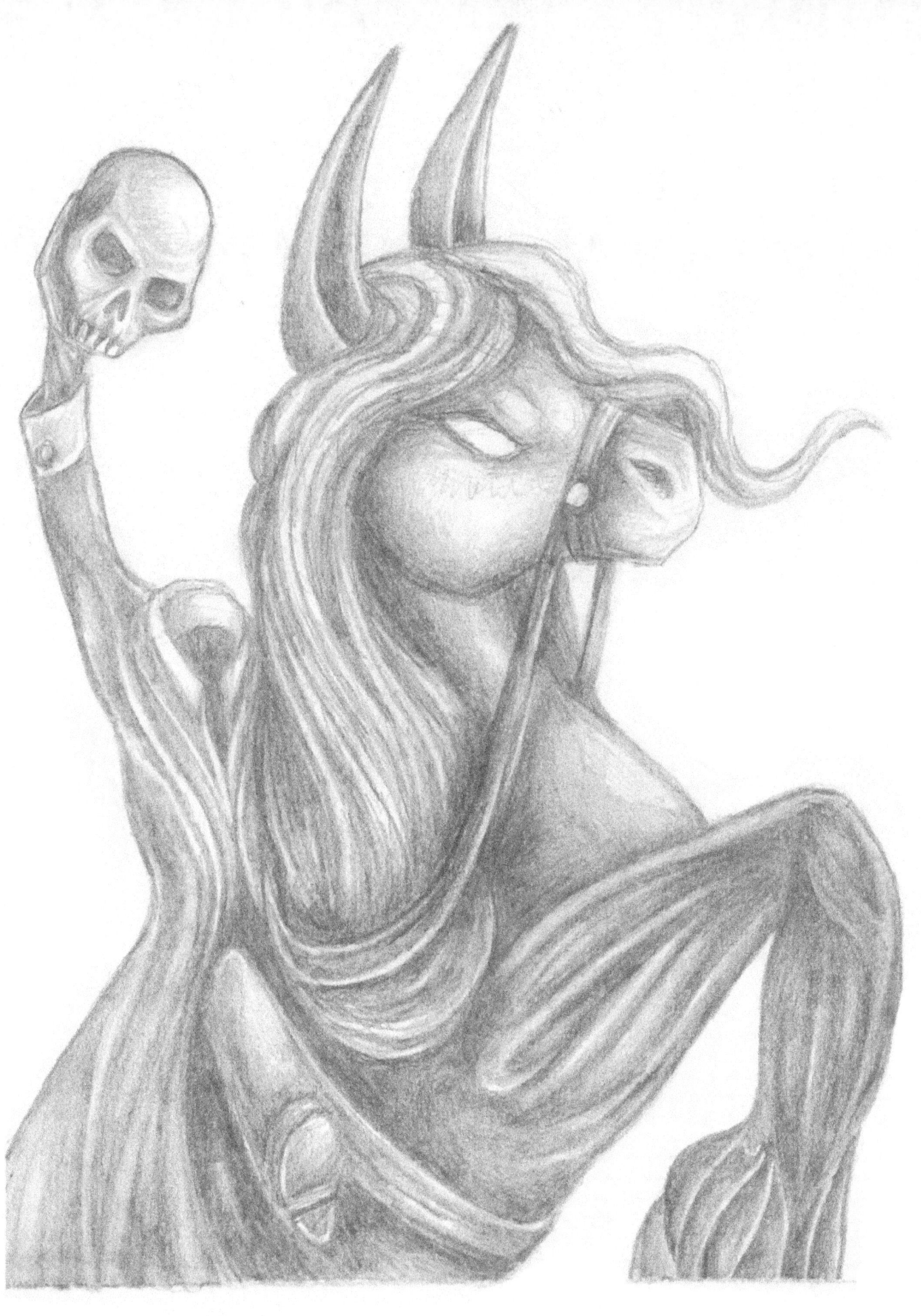

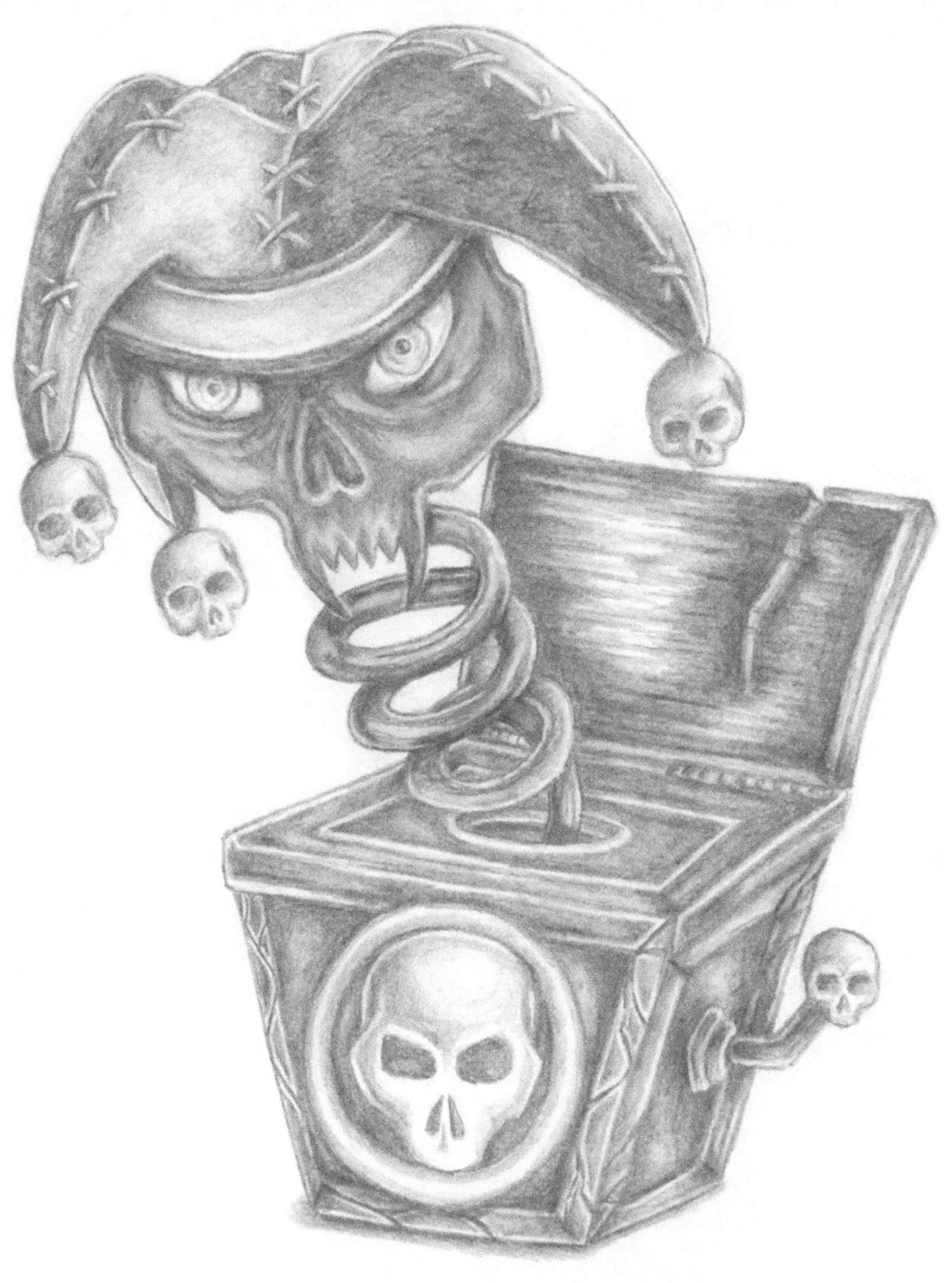

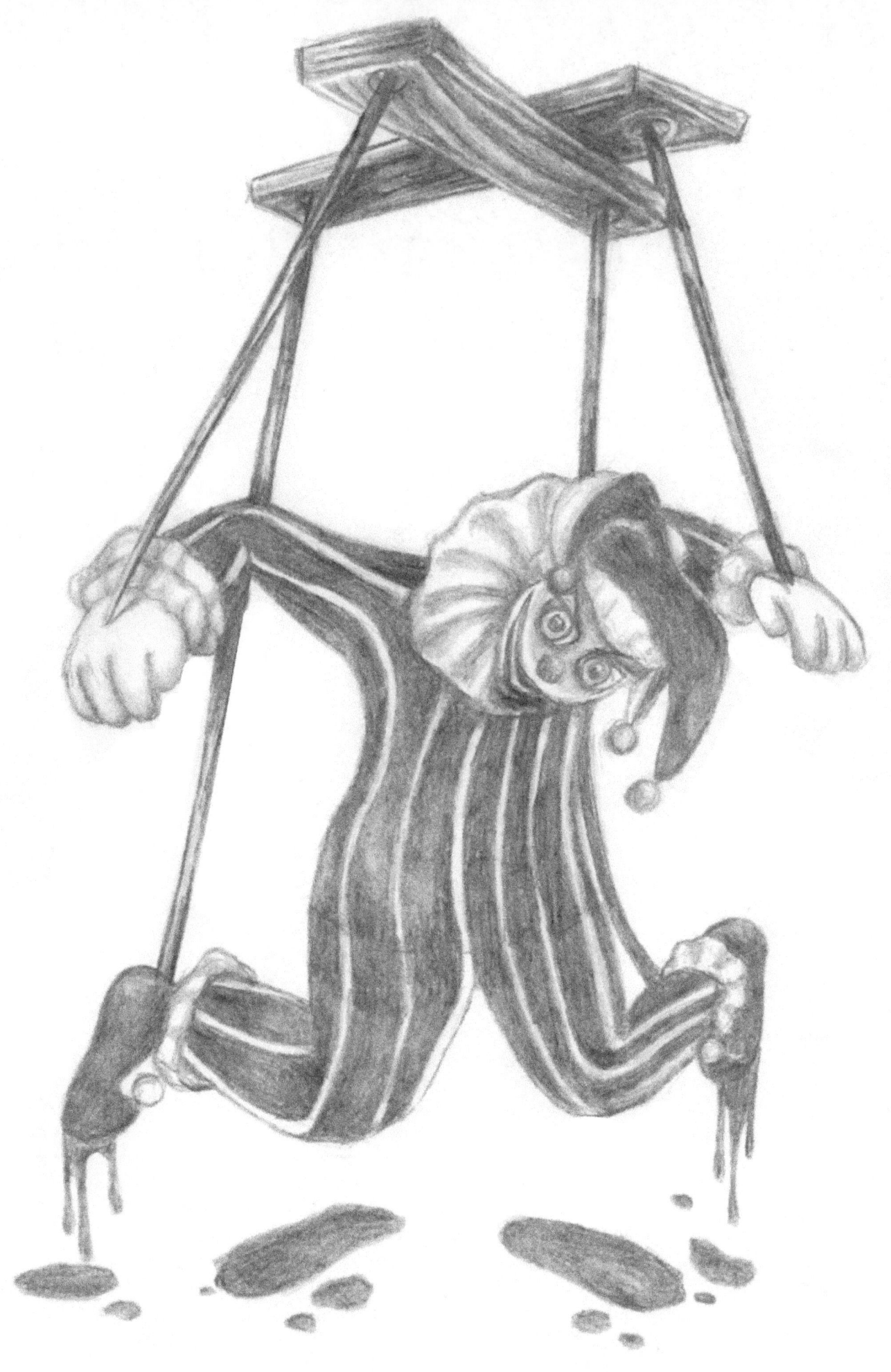

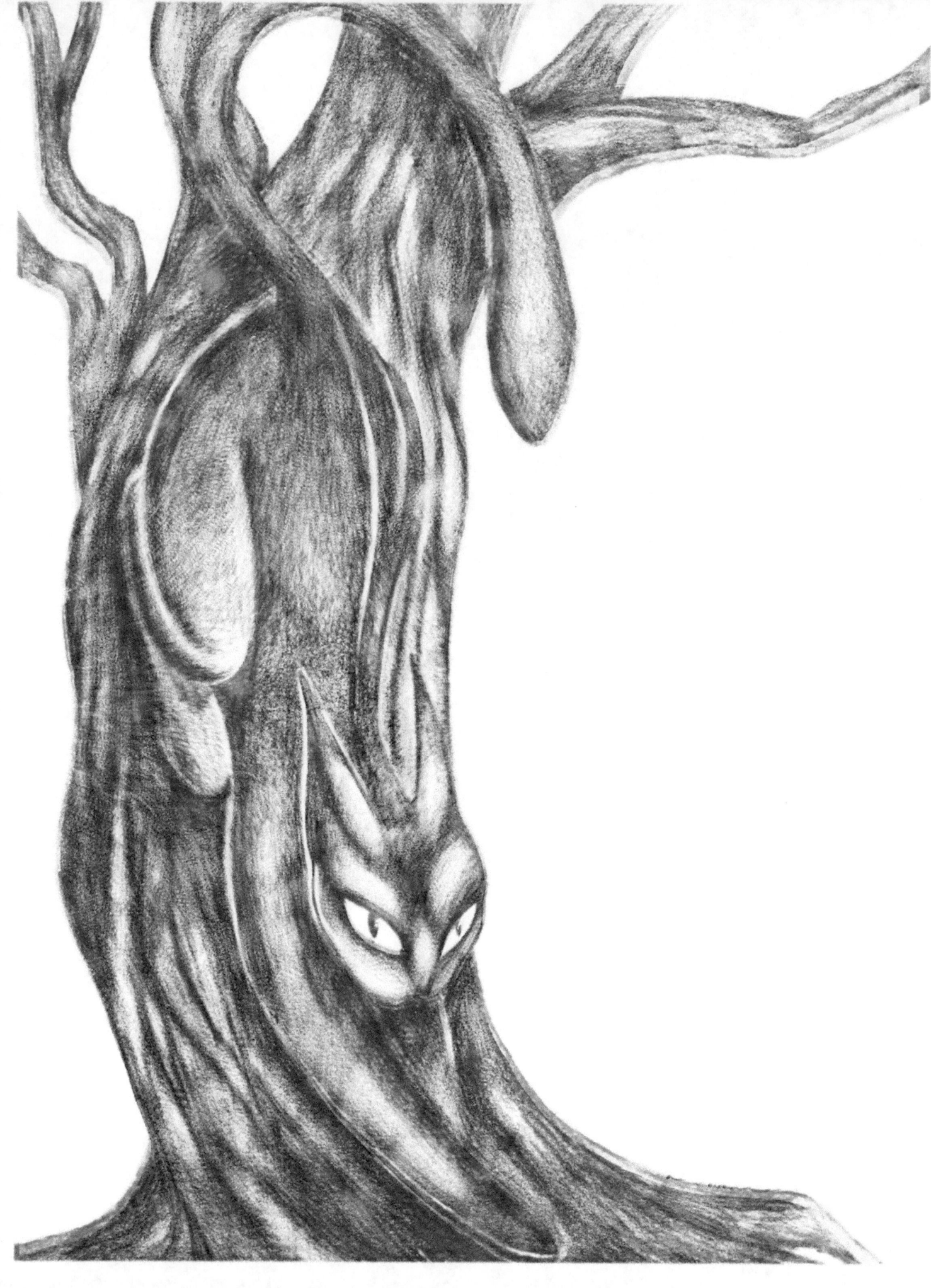

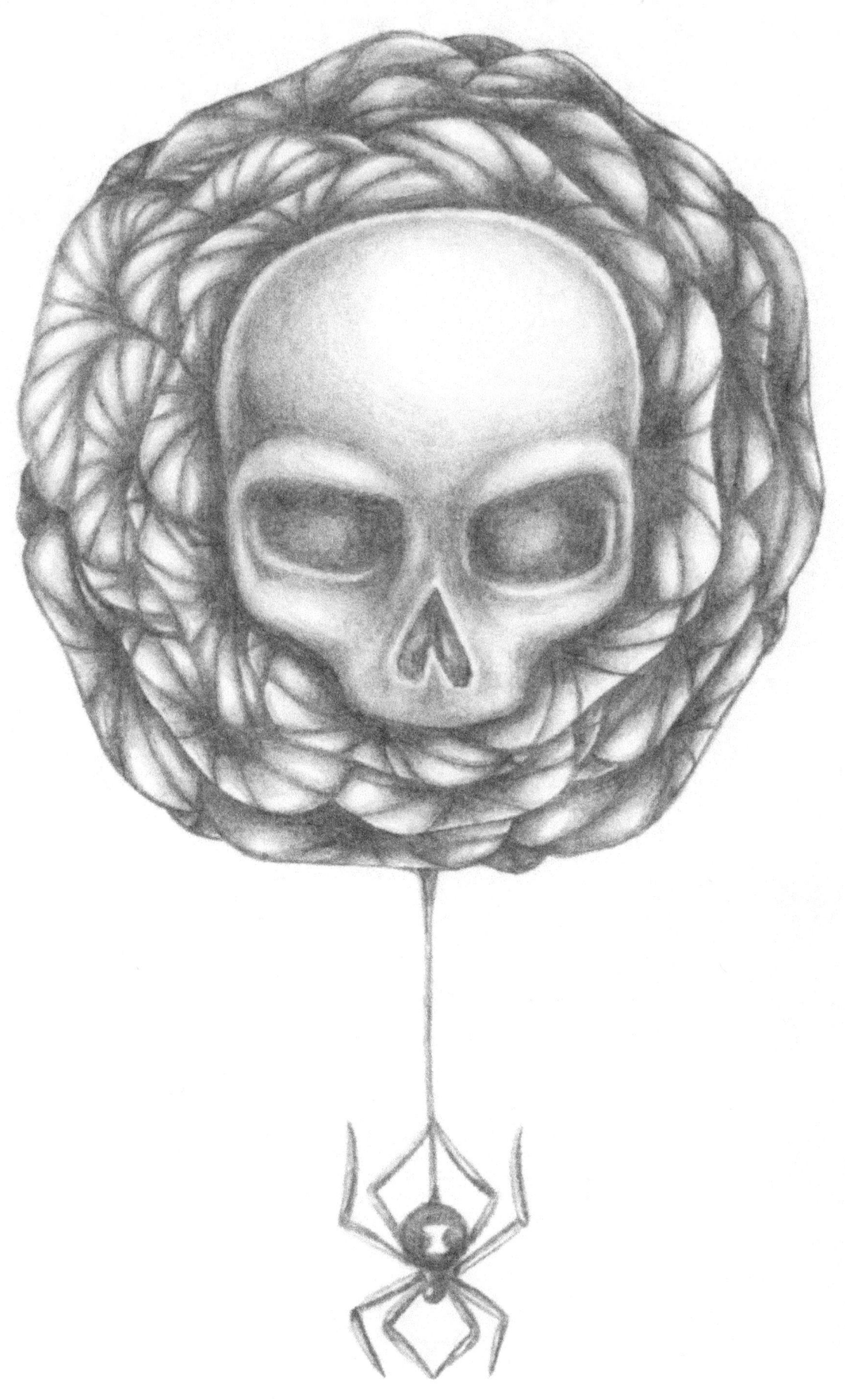

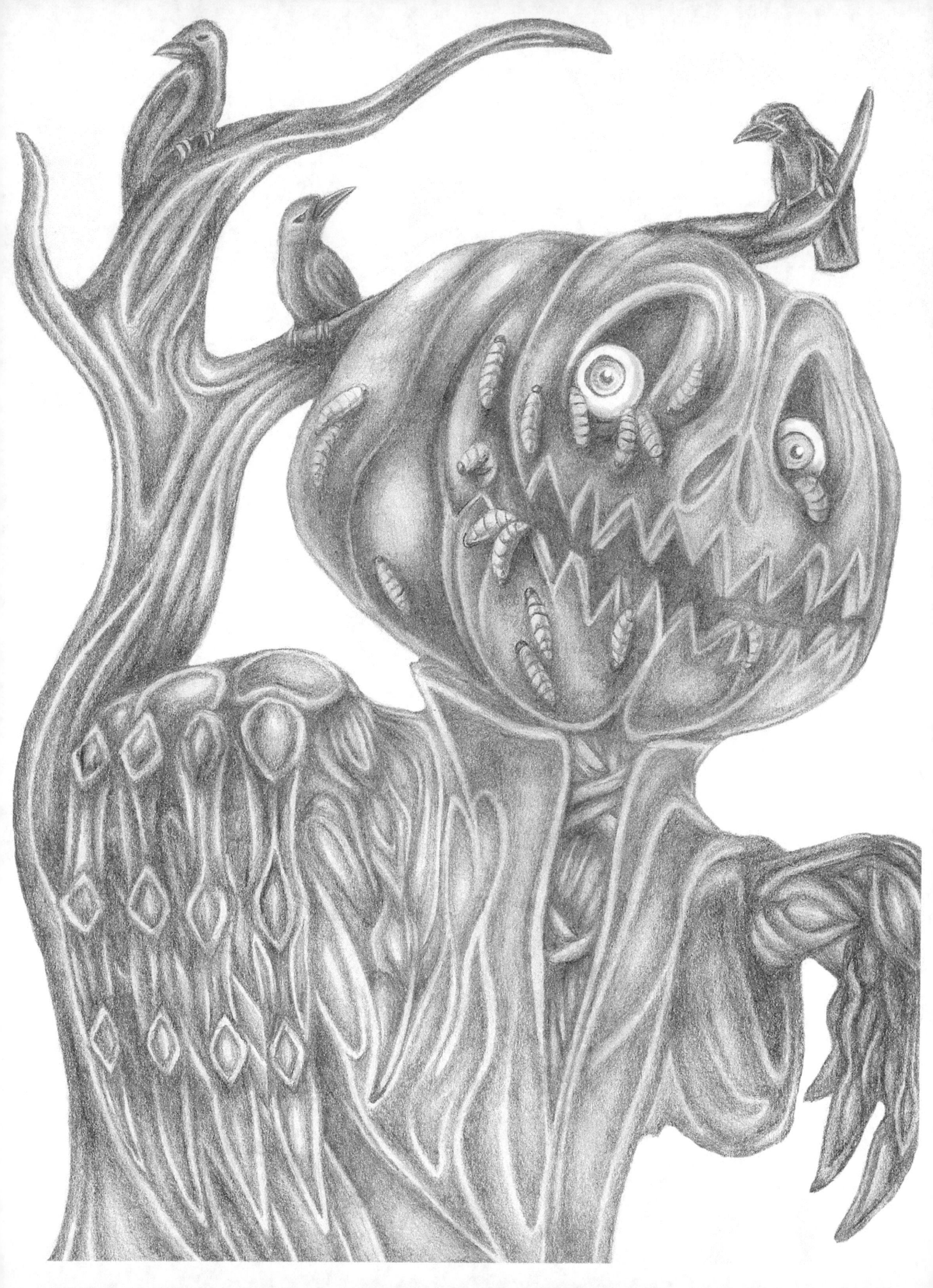

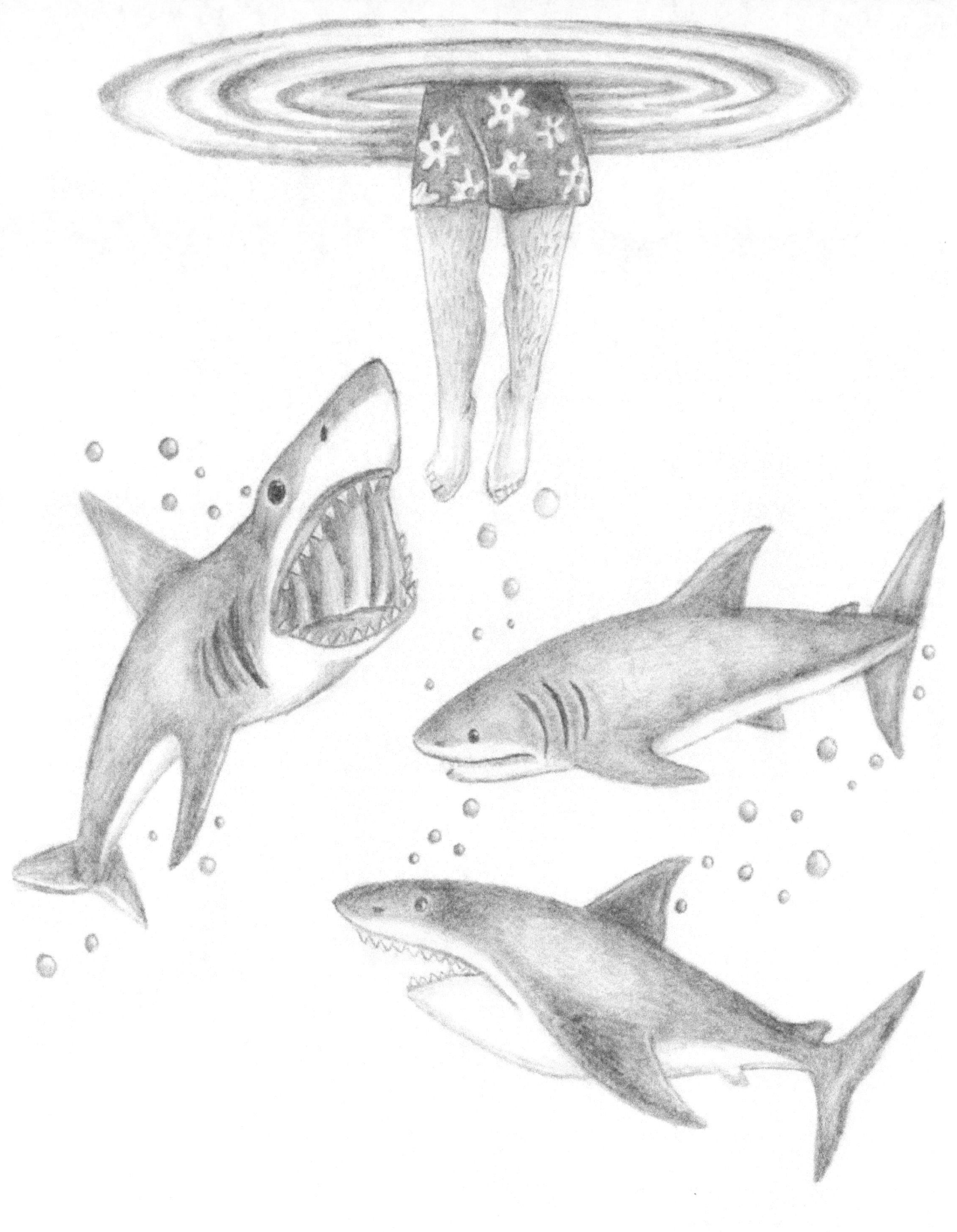

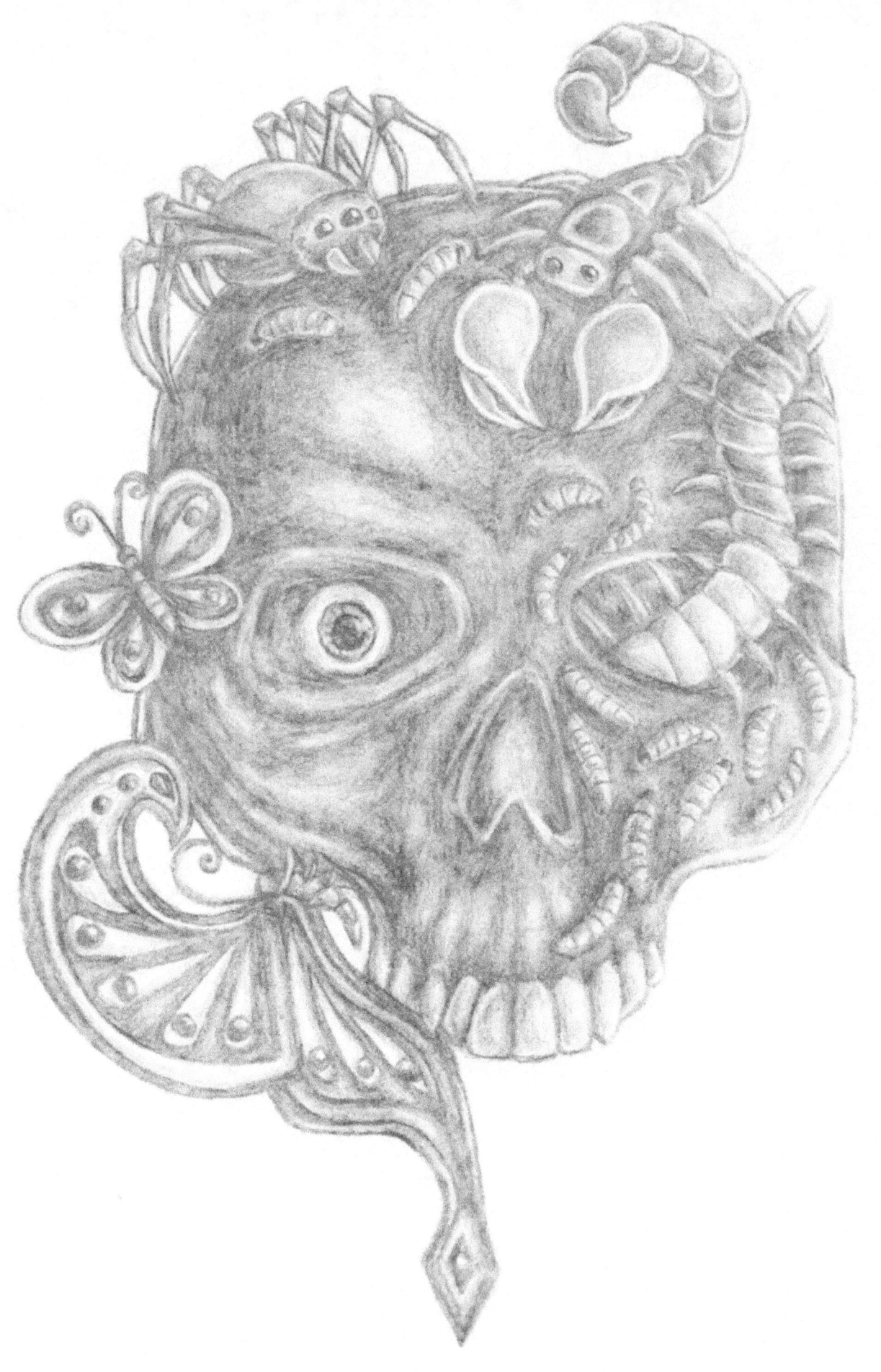

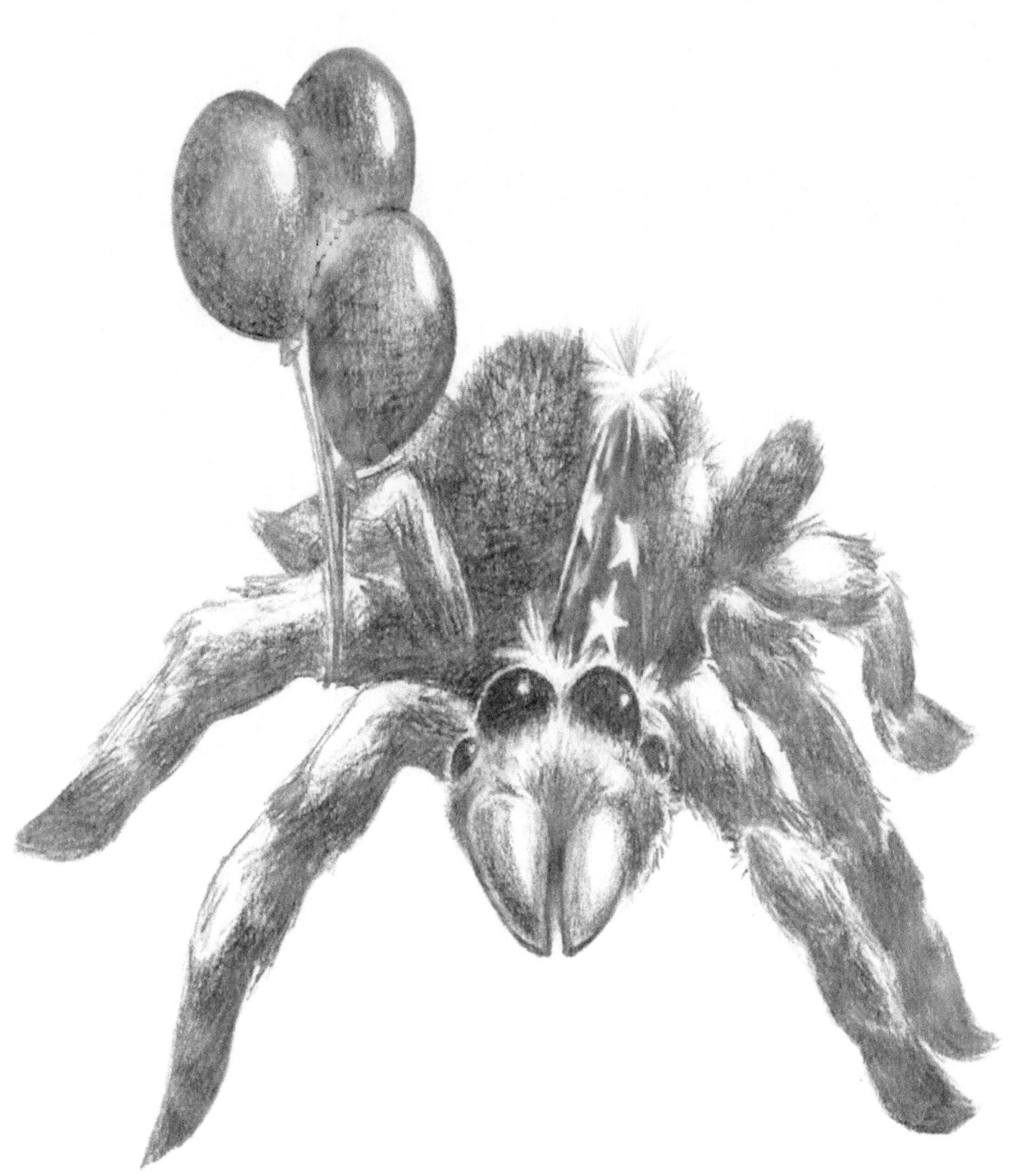

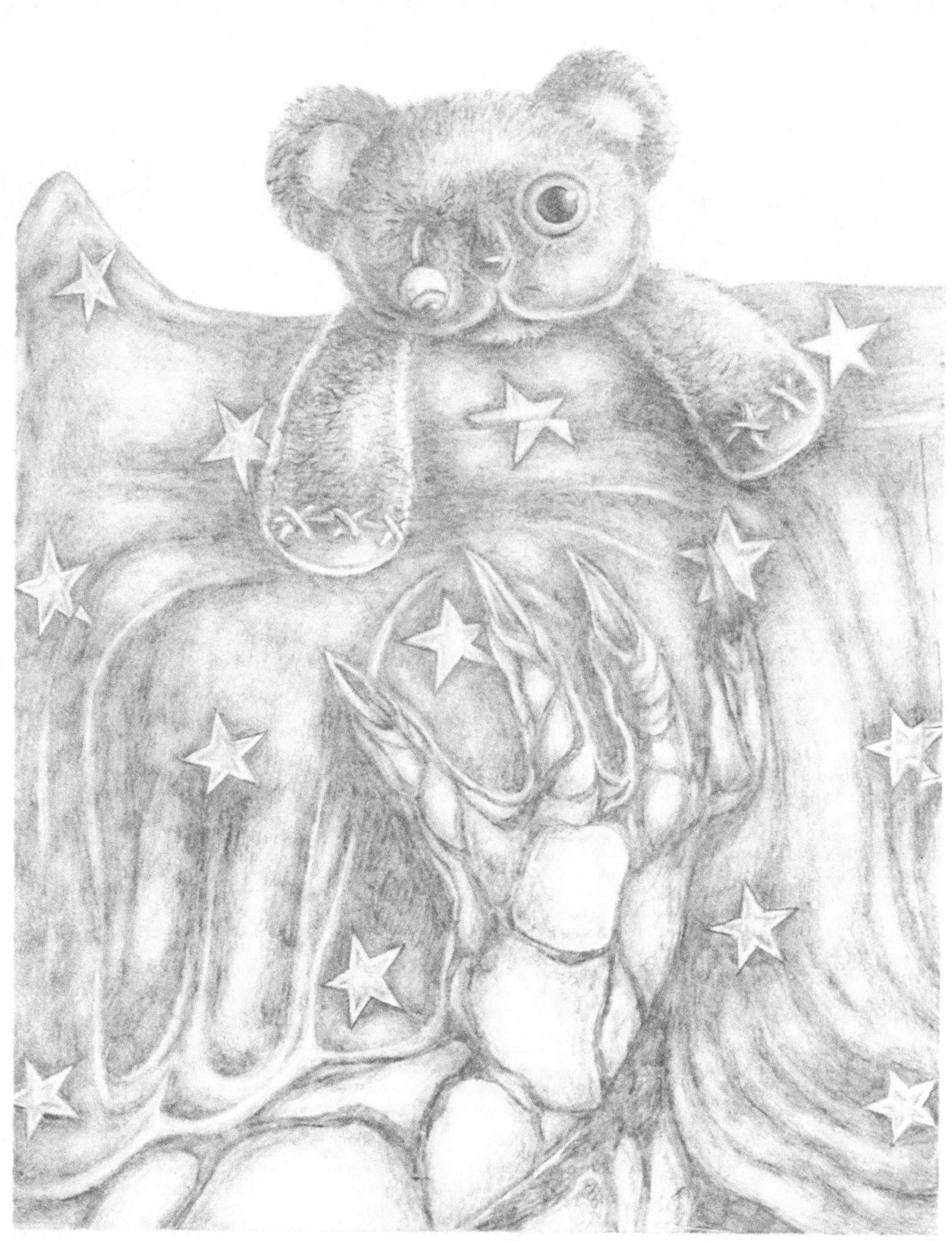

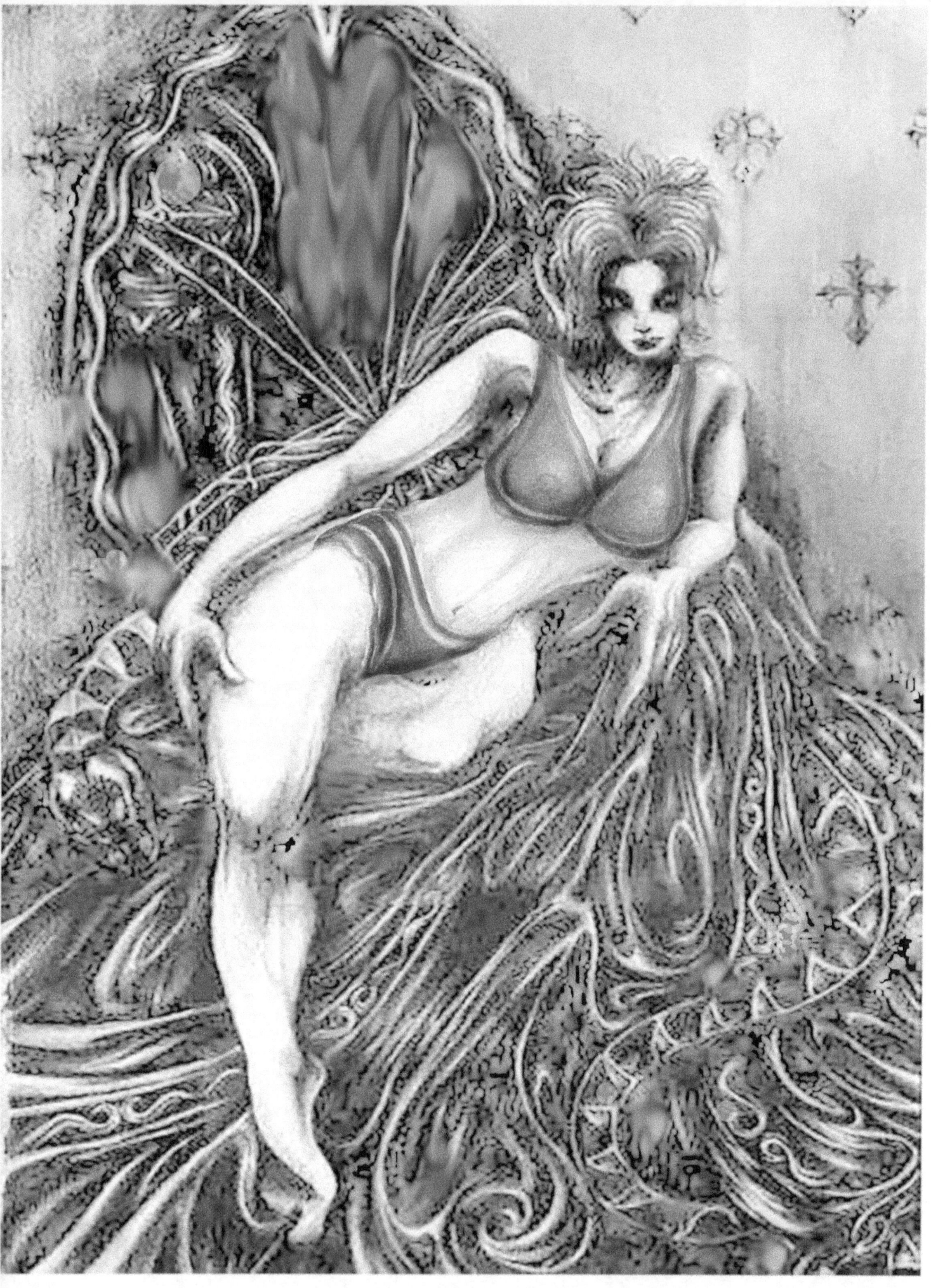

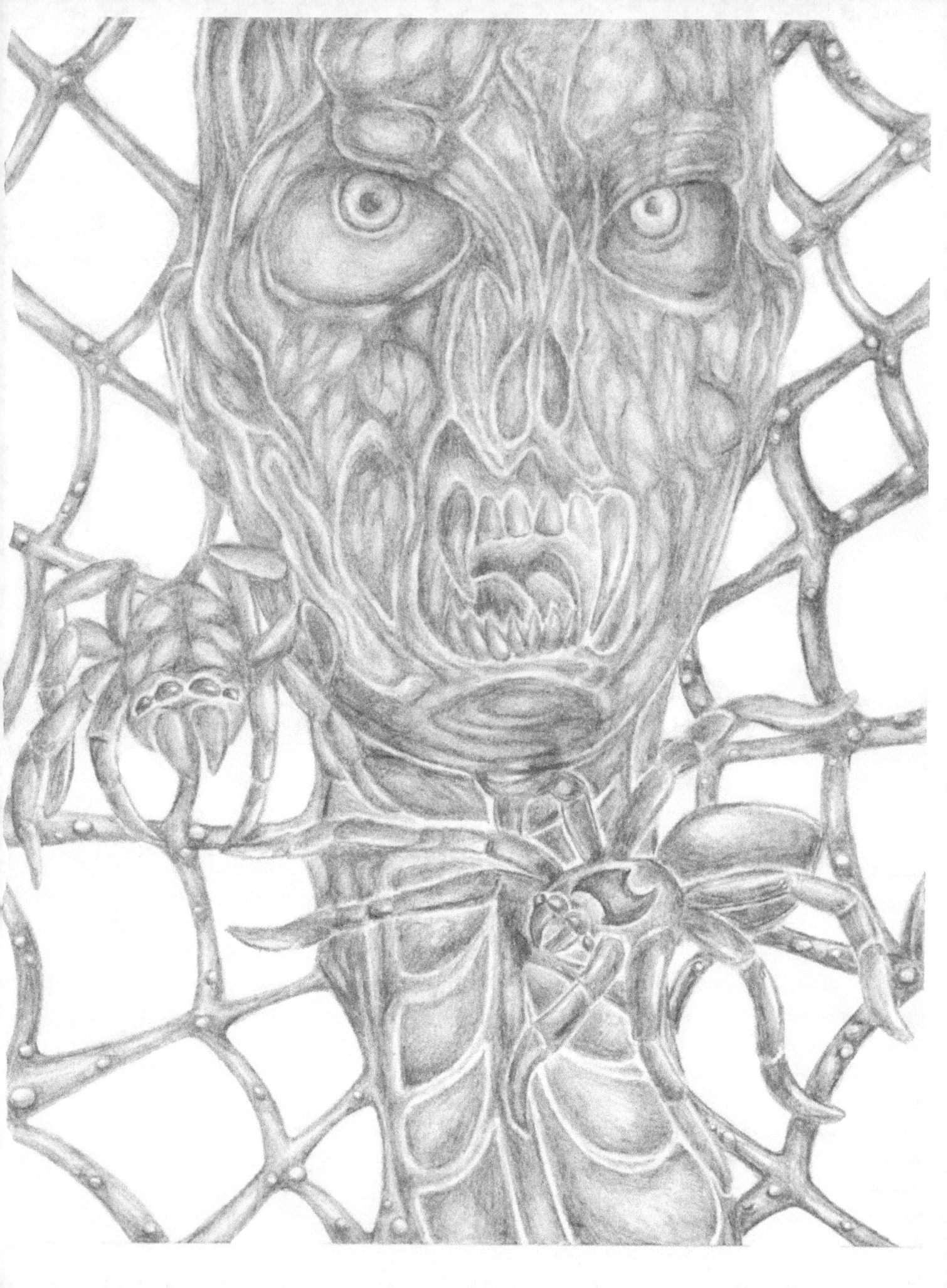

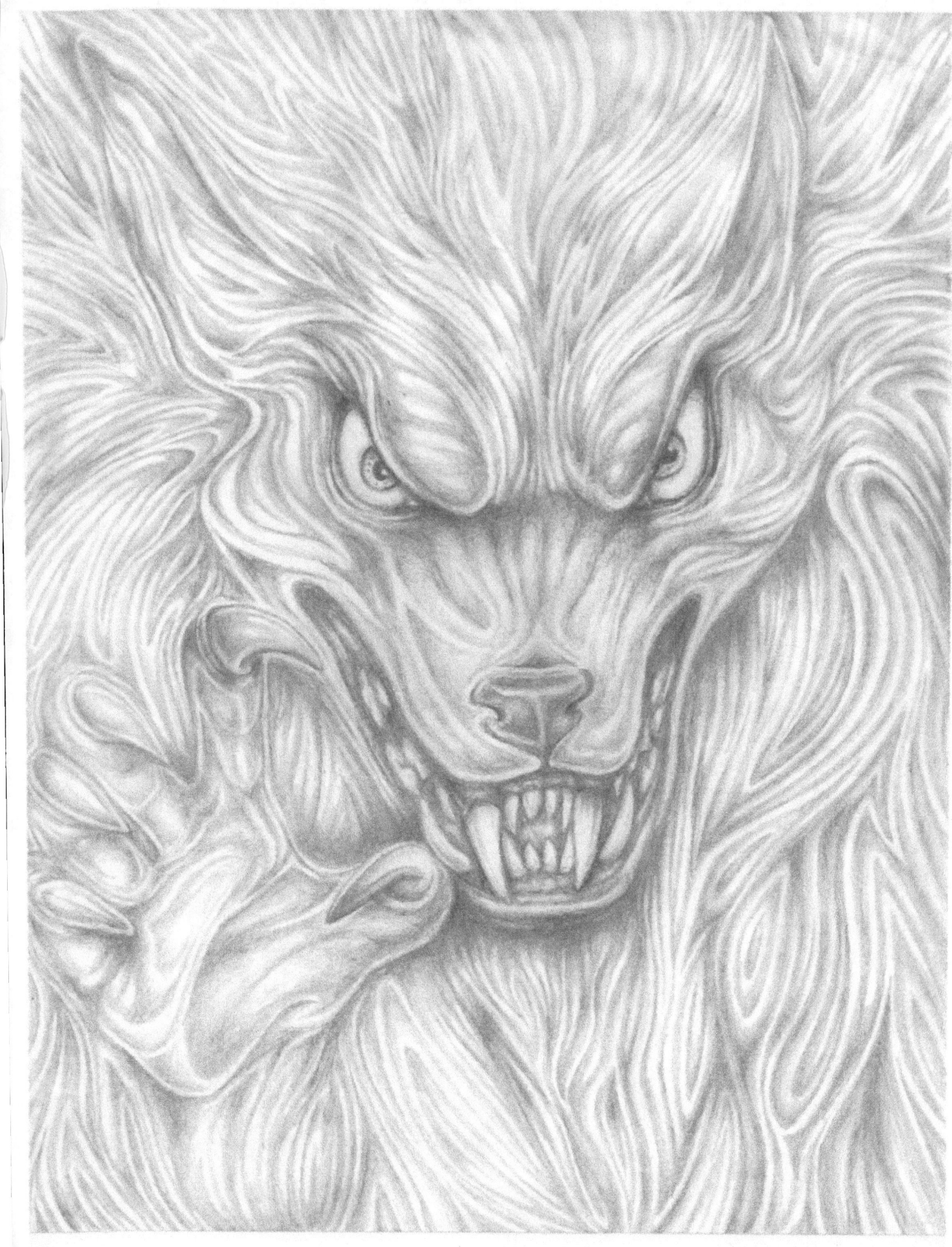

www.ingramcontent.com/pod-product-compliance
Lightning Source LLC
Chambersburg PA
CBHW080604190526
45169CB00007B/2870